W9-CDZ-791

PHAIDON
non mint copy

Mark Durden

DOROTHEA LANGE 55

Φ

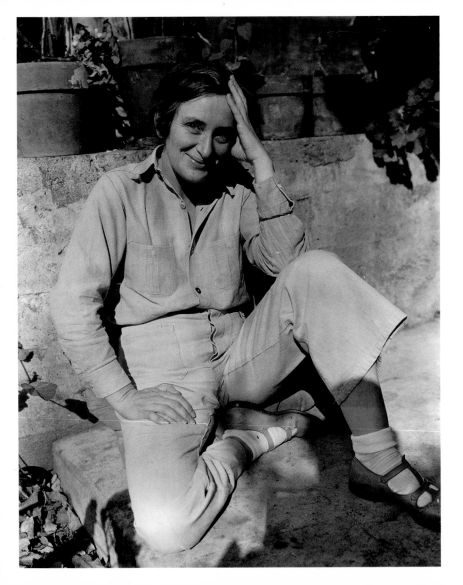

2.3

When Dorothea Lange turned her camera on the unemployed gathering in relief lines near her studio, she brought with her the experience and knowledge gained from her practice as a successful portrait photographer. From picturing some of the wealthiest and most prominent families in San Francisco, she now focused on the poor and destitute. It was 1933 when she first ventured out on the street with her camera. She took her brother Martin Lange along for protection. It was during the depth of the Depression, when at least 14 million people were out of work in the USA. The broader social disturbances paralleled her emotional life: with her marriage to the painter Maynard Dixon falling apart, Lange had boarded out her two young boys and set up a separate residence in her photographic studio.

Near her studio, a working-class widow known as the White Angel had set up a soup kitchen. In the photograph she made of it, Lange contemplates at a distance and from a higher viewpoint a lone man who has turned away from the others in a crowd gathered to receive their food. He is introspective, his hands held tightly together around his tin cup in an attitude that resembles prayer. His face bears a concentrated expression, reflecting, one assumes, on his lot. His eyes are hidden by the brim of his hat, a battered fedora. Form is inextricably tied to the comment that the photograph is making. Lange pictures the man as hemmed in on all sides: pressed up against the wooden railing, with the crowd behind and figures on either side of him.

White Angel Breadline is the first of a number of pictures in which Lange homes in on the plight of one individual in an expressive picture of a male subject, vulnerable, anxious, alone. 'Dorothea begins work photographing Forgotten Man. No Painting of this subject', was how the painter Maynard Dixon, her

husband, somewhat enviously responded to Lange's new photographic departure. Dixon sought to paint what he saw as the authentic culture of the American West; he was drawn to the exoticism of Native Americans, ranchers, cowboys, the Hispano-Americans of Taos, New Mexico, where he and Lange had been staying before their return to San Francisco in 1932. In many senses, his attachment to the West was caught up in the past, an idealizing and romantic attraction to a way of life in which individuals were seen to command their own destinies and shape their own universe. Lange's street photography in many ways countered such idealism: her lone figures were bereft of any heroicizing vision – lost, trapped, enslaved by poverty.

Lange's photography reveals a particular sensitivity to the body's gestures and postures. John Szarkowski, then curator of photography at New York's Museum of Modern Art, has spoken of how she 'was marvellous with gesture. Not just the gesture of a hand, but the way that people planted their feet, cocked their hips and held their heads.' In a recent essay on Lange, Sally Stein has suggested that the photographer 'viewed the trials of the Great Depression as something registered and grappled with first and foremost in the body'. It is tempting to see this sensitivity to the body as linked to the legacy of her illness – a bout of polio in her childhood had left her with a pronounced limp. In the early 1960s she described the impact of her handicap: 'it formed me, guided me, instructed me, helped me and humiliated me.' In later life, Lange was debilitated by serious and extended bouts of ulcers and oesophagitis, her illness interrupting and preventing many of her planned projects.

In *White Angel Breadline*, the predicament of the lone man is conveyed less through facial expression – we can't see his eyes – than through his physical

stance, trapped by the crowd and railing. In other works, the Depression's effects are also revealed through details: her remarkable photographic close-up, for example, of the legs of a stenographer, her mended stockings an index of hard times, but also suggestive of a certain spirit in the face of straitened circumstances.

As Sally Stein points out, there is a recurrence in Lange's photography of a body that leans, a body that is propped up. Many of her photographs show 'bodies bent out of shape by labour', or bodies so contracted they refuse to connect with external objects. An example of this introverted body is perhaps best shown by her photograph of a man with his lowered head buried in his hands, his back against the wall, beside him his wheelbarrow, overturned, as Lange has described it, 'like his livelihood'. Because he is photographed in strong lighting, shadows give this seated figure a graphic simplicity. *Man Beside a Wheelbarrow* thus functions not so much as a portrait, but as an abstract icon of despair: the unemployed man remains faceless; all we see is the cap on his bowed head – its shape and pattern rhyming with the wheel of the barrow. The aridity of the environment, the empty space of the blank wall behind him, the symbolic charge of the overturned wheelbarrow, all further reiterate the message of despair and helplessness.

It is not just the oppressed who are pictured; Lange's photography also involves a subtle critique and exposé of figures of authority and power. Again, it is the gesture and posture of the body that is revealing. Her well-known photograph of a street demonstration, for example, highlights the commanding presence of a large policeman, standing legs wide apart, his fingers laced together, pictured in profile, looking out of frame left, with the star of authority

on his chest. If one is to see this as a portrait of a figure of authority, then there is little point of identification with him. Because he is photographed in profile, he gives us no eye contact. Instead, one is drawn to the relationship between the photographer and the protesting crowd on whom the policeman has turned his back, particularly the final figure, who seems to be looking directly at Lange. Scanning the crowd from left to right, other figures appear to turn towards us, distracted from the object of their gaze out of frame by the presence of the photographer. And we are left, finally, with the concerned, curious look of the bespectacled man, a natural portrait of a protester, which cuts against the policeman's theatrics of power.

There is generally felt to be a shift from Lange's photographs made in the streets of San Francisco to her pictures of migrant labour. She has described this difference in her approach to subjects in city and country: 'I had begun to talk to the people I photographed. For some reason ... the people in the city were silent people ... But in the migrant camps, there were always talkers ... It gave us a chance to meet on common ground – something a photographer like myself must do if he's going to do good work.' Lange's photography of migrant labour was indebted to her relationship with the agricultural economist Paul Taylor, who, after she divorced Dixon, became her second husband in 1935. It was through observing him conduct his field research that she started to talk to the people she photographed. This dialogic model has generally led critics to describe many of her pictures of the plight of migrants in terms of an empathy towards those photographed. Words spoken by those she pictured often accompanied her photographs. Her work is generally valued in terms of the pride and strength of her subjects. In the midst of despair, she finds a certain dignity and courage. Her pictures do not simply portray the poor as

victims – helpless, abject and pitiable. In this respect, they differ from those of photographer Margaret Bourke-White, who travelled the South with the writer Erskine Caldwell in 1936, presenting a series of portraits of a rural people defeated and wasted in the popular book *You Have Seen Their Faces*.

While California had been home to a steady supply of low-wage migrant labour from abroad, white American farmers suddenly started flooding in with their families, driven from their farmsteads in the Great Plains states by a combination of the process of farm mechanization, the effects of the Depression and a series of droughts and dust storms that began late in 1933. Up until 1939, some 350,000 farmers deserted their homesteads and headed for California.

In 1935 Lange joined the staff of Paul Taylor on the State Emergency Relief Administration. Taylor was a strong advocate of the establishment of camps for migrant workers, and hired Lange to photograph farm labourers throughout the state of California. A report on migrant workers, illustrated with Lange's photographs, came to the attention of Roy Stryker, who invited her to become a staff photographer for the Resettlement Administration (RA), later the Farm Security Administration (FSA), an arm of the Department of Agriculture, which was created to deal with the problems of the poorest farmers. Through Stryker, the FSA provided an extensive photographic record of the transformation of American agriculture and the migration of Americans and their families, driven from their land by the tractor and the Dust Bowl. Working with the FSA, what was expected from Lange and other photographers in their work was a particular liberal, positive attitude, which Stryker described as 'a deep respect for human beings'.

Among some of Lange's first field photographs in California is a dignified and respectful portrait of a black pea-picker from Texas (page 25). He is sitting by the roadside facing the camera, looking Lange, and therefore the viewer, straight in the eye. This empathetic, sensitive portrait provides a striking contrast with her scathing picture of an overweight pea contractor in Nipomo, California, photographed in profile so that the full obscenity of his well-fed belly is highlighted (page 27). As with her street photography, Lange was not just picturing the oppressed. As she put it: 'The art under which you work, of course, was people in trouble, that was the big art, and you can't do people in trouble without photographing people who are not in trouble, too. Because you have to have those contrasts.'

Again, many of her pictures focus on the expressive potential of the body's gestures. A number of the portraits are full length, as attentive to posture (the way the subjects physically compose themselves before the camera) as the expression on their faces: the graceful upright stance, for example, of the black woman standing in the shade of a billboard by the roadside, counterposed by her husband crouching behind her (page 93); or the patient endurance of an older man waiting for work, squatting on the edge of a pea field – another compassionate portrait. In order to take it, Lange too must have crouched down in the field.

The corporeal aspect of Lange's photography is particularly evident in her isolation of details of the body. An example is her study of the way in which hands hold a primitive hoe. This photograph is very much about touch – evident not only through the peculiar grip of the hands on the wooden handle, but also through Lange's fascination with the textures, clearly brought out through

strong lighting of the labourer's patched and worn clothing. She has spoken of how this photograph is intended to show the way in which the worker is tied up with the land. In *Migratory Cotton Picker* (page 105), Lange picks out an unusual gesture in which the subject hides his mouth with his hand – apparently he wanted to conceal his bad teeth from the camera. Facing the camera, his palm blocks out some of his features; the physicality of a life working the land is conveyed through the wrinkles and lines of this thick, leathery, labourer's hand.

Lange has commented on the difficulty of photographing country people since their 'roots were all torn out ... It's very hard to photograph a proud man against a background like that, because it doesn't show what he's proud about.' In many senses, her pictures looked for an inner strength and resilience in her subjects; one that she often found and brought out in her pictures.

Lange's most famous picture, and arguably one of the most widely reproduced and familiar photographs of the twentieth century, *Migrant Mother* (page 39), was taken at the end of a long assignment for the Resettlement Administration. On her first major trip alone, she was returning home after a month on the road when a sign reading 'PEA PICKERS CAMP' caught her eye. Through the particularities of a scene of poverty and hardship, Lange found sacred allusions. Also known as *Migrant Madonna*, her photograph visualized the trauma of the times in terms of a cherished icon of Western art. But the mother's face bears, as the writer Alan Trachtenberg has put it, 'a worried rather than a beatific look', and the children are not 'lolling in bliss but clinging for protection'.

Like Stryker, Lange believed that photography was a tool of political action. It could and did effect change. As soon as she had printed the negatives, she went

to tell the City Editor of the *San Francisco News* of the migrants' plight. He notified United Press and on 10 March the *News* ran a report that the federal government was rushing in 20,000 pounds of food to feed the hungry migrants at the camp. Alongside the headline ran two of Lange's pictures, but not the now famous photograph.

In her account of picturing the migrant mother, Lange refers to taking five photographs, 'working closer and closer from the same direction'. In fact, she took six pictures, submitting five to Stryker and withholding one, probably for aesthetic reasons. James C. Curtis suggests that it was a trial shot, made soon after she got her equipment out of her car, a means of easing her subjects into posing for their portrait session. Considering these images in terms of a series culminating in the well-known portrait of the migrant mother, one gets the sense both of a careful arrangement of the mother and her children and the progressive editing out of distracting and seemingly irrelevant details. The particularities of context are erased to achieve a more abstract and thereby universal representation of poverty.

Many of the new migrants arrived in cars, and the overcrowded automobiles could contain up to three generations of a family and all their possessions. Lange and Taylor described the car as a new 'covered wagon'. But the open road to the West – Lange photographed these long roads on a number of occasions, both empty and with migrant families travelling along them on foot – now contained little sense of destiny and hope.

Lange was also fascinated by the precarious and improvised structures that constituted the migrants' transitory homes. Her photographs of these flimsy,

fragile structures should be seen in relation to her vivid studies showing the devastated family farmsteads that had been left behind. In Texas, she began her camera study of abandoned tenant homes, many tractor-cultivated right up to the door. They are pictures of a desolate landscape: the regular mechanical furrows left by the tractors, and the elegiac empty houses, bereft of trees, fences, gardens.

Despite the suffering induced by the Depression, billboards bearing big-business clichés about American life – 'World's Highest Wages: There's No Way Like the American Way' – continued to flourish in the 1930s. Such billboards were part of what *Life* magazine called a propaganda campaign by the National Association of Manufacturers. Lange often drew upon the ironic contrast set up between these messages and the plight of migrants, who would on occasion set up their transitory homes beneath the shelter of these advertising signs. She also photographed billboards advertising the Southern Pacific railroad. In one picture she shows migrant workers trudging on foot past an advert inviting people to relax and take the train (page 57). Her sensitivity to signs is also revealed in another work in which she captures a defiant message, painted beneath an air-pump sign at a roadside garage in Kern County, California, which reminds those who need air for their tyres that it, like their country, is free, and that they should not let 'the big men' take it away from them (page 87).

On her first trip to the Mississippi Delta, Lange came upon a plantation store that furnished the scene for one of her best-known photos, *Plantation Overseer and His Field Hands* (page 45). The photograph shows an overweight, white man who stands in the foreground, one foot planted on the bumper of his shiny car; behind him are his five black workers. The physical presence of the figure,

amplified and echoed by the curved boot of his Ford, links him with Lange's earlier portrait of a pea contractor – both subjects appear to be engaged in conversation with someone, presumably Taylor, out of frame. Her son, Dan Dixon, told how, in this first trip to Mississippi, she 'ran up against a problem she'd never encountered before. Up until then, most of her work had been done in areas where the Depression had shaken apart any form of social order. But in the South, a social order remained, and it held so tenaciously to those who lived under it that in order to photograph the people she had to photograph the order as well.' In *Plantation Overseer*, Lange captured the image of a man who exemplified the racist, exploitative and un-democratic attitudes that were rife in Southern plantation life. The evidence of racism revealed in this photograph and others – her picture of the Rex Theatre 'for colored people' (page 65), the unkempt 'Negro cemetery' (page 98), with rocks as grave markers, for example – is countered by her many dignifying portraits of black subjects.

The social unrest and unemployment of the Depression ended with America's preparation for war. On 19 February 1942 President Roosevelt signed the now infamous Executive Order 9066, which allowed military commanders to set up military zones wherever they thought necessary and gave them the power to remove anyone they wanted from these areas. A few weeks later, there was an order that all persons of Japanese descent must leave the Pacific Coast military areas: 110,000 men, women and children were told to report for internment in camps outside the military zones. The War Relocation Authority wanted to document its work and Lange was assigned to record the evacuation in Northern California. She strongly opposed the removal of these people from their homes. According to critic A.D. Coleman, the photographs she made of the

evacuation were some of her 'most poignant and angry pictures'. He compared them to her images of the Depression, revealing 'her concern with the survival of human dignity under impossible circumstances'. Showing the quiet patience of these families in such dehumanizing conditions, the photographs function as a powerful exposure of American racism and wartime hysteria.

For an assignment for *Fortune* magazine in 1944, Lange worked together with the photographer Ansel Adams on a twenty-four hour sequence of images showing the life of shipyard workers at Richmond, an industrial town on a headland jutting into San Francisco Bay. Women, though they found jobs here because their labour was so badly needed, got no warm welcome from the men in the plants and shipyards. Such tensions are vividly brought out in her striking picture *Argument in Trailer Court* (page 117). Lange's friend, Homer Page, describes how Adams was interested in the more grandiose aspects of the shipyard while Lange was concerned with 'the intimate aspects of workers' lives. She was interested in the flow of things.' He also sheds light on the background to Lange's trailer court photograph 'of the man and woman glaring at each other'. They were husband and wife, 'uprooted from Oklahoma, wandering 1,000 miles from home to enter a radically different kind of life, and driven apart by the pressures of long and conflicting hours. Their inner relationship is revealed at once in that shot. It's the space between that counts.'

Lange suffered recurrent illness from stomach ulcers throughout the 1940s. From 1945 to 1950 her work came to a virtual standstill. In the spring of 1955, she began work on a photo-essay for *Life* magazine, a sensitive study of the work of a Yugoslav-American public defender, representing those who could not afford to pay their own legal expenses. Lange watched and photographed him

on and off for a year; in the office, courtroom and jails. Despite her subject matter, she avoided sensationalism; offering instead subtle, expressive representations of this attentive lawyer and his clients.

For one of her last great projects, Lange returned to the photography of the open land and a contemporary social issue that was clearly linked to her documentation of human migration of the 1930s. Through her younger son, she learnt of a place forty-five miles north of California, the fertile Berryessa Valley, which was to be flooded to make a reservoir to supply the constantly rising demand for water of California's growing population. Together with Pirkle Jones, an assistant to Ansel Adams, she photographed the devastating changes in the valley in 1956–7. As in the tractored-out landscapes that she had pictured during the Depression, devastation to the land was seen in terms of human dislocation and upheaval. Even the dead did not rest in peace, as revealed in Lange's images of the barren, desecrated scene after grave diggers had disinterred bodies from their burial sites. Her photos of the Berryessa Valley stand as a clear indictment of the break-up of a rural community. *Life* originally commissioned the story but abandoned it to cover a flood in Texas. The photographs were finally exhibited under the title *Death of a Valley* in the San Francisco Museum of Art and published as a photo-essay in *Aperture*, a photographic journal that Lange had helped found.

In the last decade of her life, when her illness had grown worse, Lange began to teach what she had learned. Well enough to teach only two seminars at the California School of Fine Arts, she concentrated on the importance of persuasion as one of the photographer's roles. 'Bring the viewer to your side,' she said, 'include him in your thought. He is not a bystander. You have the

power to increase his perceptions and conceptions.' Though Lange had always been uneasy with the term 'documentary', if one is to find a definition of the term that comes closest to her photography, it is that given by Beaumont Newhall when he was Head of the Department of Photography at the Museum of Modern Art. In an article in 1938, he wrote that the documentary photographer will not 'photograph dispassionately ... he will put into his camera studies something of the emotion which he feels toward the problem, for he realizes that this is the most effective way to teach the public he is addressing.' Documentary photography for Lange was certainly never bereft of feeling or persuasiveness. Her images had a function: to engage and rouse the viewer to action. The people she photographed maintained a certain resilience in the face of suffering and it is a recognition of and identification with this strength that runs through so many of her distinctive photographs. Roy Stryker might have been speaking of most of Lange's work when he identified the tension in the images taken for the FSA as 'Dignity versus despair', and concluded 'I believe dignity wins out.'

White Angel Breadline, San Francisco, 1933. At the height of the Depression when the unemployed were wandering the streets outside her studio, Lange found it difficult to continue her commercial portraiture of some of the wealthiest families in California. 'The discrepancy between what I was working on in the printing frames and what was going on in the street was more than I could assimilate. I knew that if my interests in people were valid, I would not be doing only what was in those printing frames.' This photograph was the result of her first venture out on the street with her camera. It invites us to identify with the plight of this pensive, elderly figure who has turned away from the others in the crowd, waiting for their food at a soup kitchen.

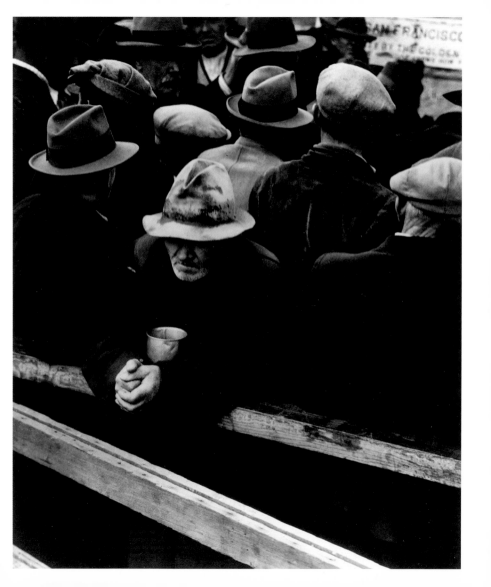

Man Beside Wheelbarrow, San Francisco, 1934. Lange began to go out on to the street at every chance she could get. She has said: 'I'd begun to get a much firmer grip on the things I really wanted to in my work. This photograph of the man with his head on his arms, for instance – five years earlier, I would have thought it enough to take a picture of a man, no more. But now, I wanted to take a picture of a man as he stood in the world – in this case, a man with his head down, with his back against the wall, with his livelihood, like the wheel-barrow, overturned.'

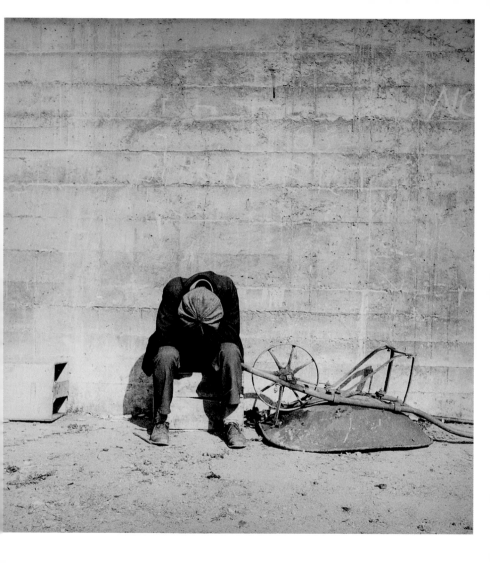

A Sign of the Times – Depression – Mended Stockings, Stenographer, San Francisco, 1934. Lange was able to show the effects of the Depression not only through portraits but through details. This striking close-up of the mended stockings of a stenographer provides a somewhat amusing glimpse into one woman's response to her circumstances. One could compare it to the detail of the worn fedora in the portrait of the man in *White Angel Breadline* – an attempt to preserve a certain dignity of appearances in the face of adversity. Better to be seen with stitched and repaired stockings than none at all.

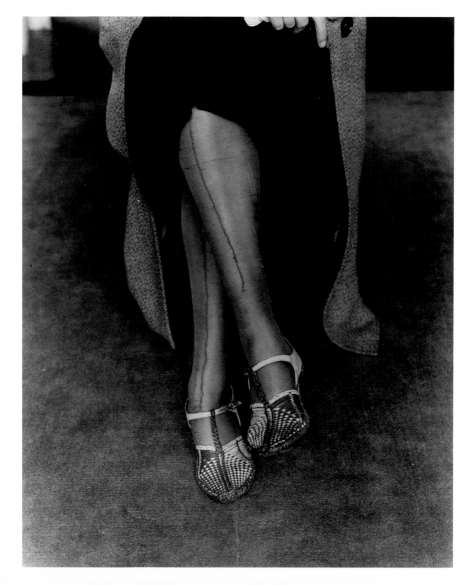

San Francisco's Street Demonstration on the Edge of Chinatown, 1934. This picture has often been mistakenly identified as a picture of the General Strike in 1936, but, as the picket signs show, it documents a protest against the sending of scrap metal to Japan. It is a study of the theatrics of power, communicated through the policeman's authoritarian stance. Lange's identification and sympathy rests with the protesting crowd behind him.

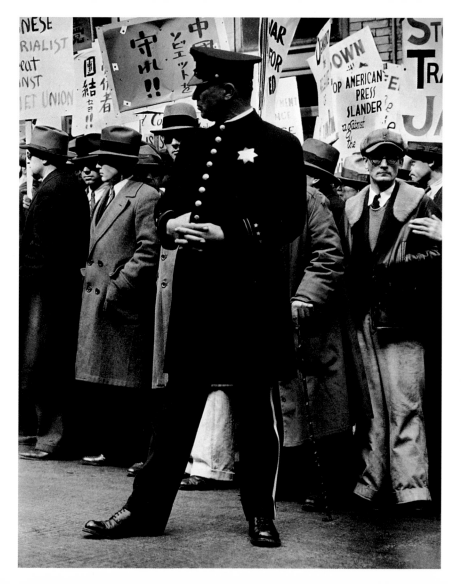

One of a group of single men by the roadside. They have come to work in the pea fields. Nipomo, California, January 1935. Lange's husband Paul Taylor invited her to join his study group on their visit to Nipomo for the pea harvest. The experience altered her practice decisively: 'I had begun to talk to the people I photographed. For some reason … the people in the city were silent people … But in the migrant camps, there were always talkers. It gave us a chance to meet on common ground – something a photographer like myself must do if he's going to do good work.' This portrait of a black pea-picker who followed the fruit crop is a clear testimony to Lange's closer relationship to subjects in the field than to those on the street. The picture speaks of collaboration. The portrait is not stolen. Instead, the young man looks calmly back at Lange, composed, dignified and relaxed before the lens.

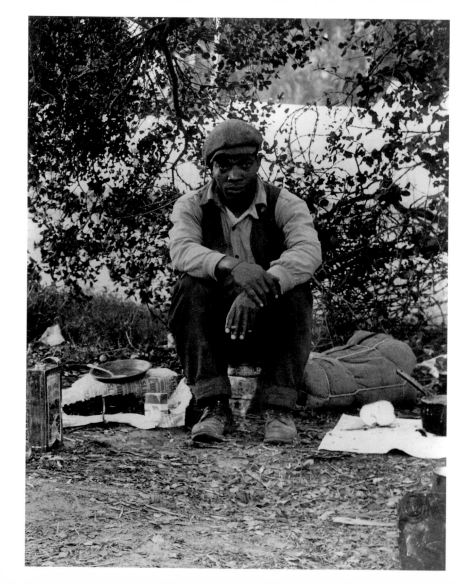

Pea Contractor, Nipomo, California, 1935. Lange's photography in the field did not simply focus on workers. It also offered distinctive representations of power and authority. It is hard not to see this portrait, taken in profile so as to highlight the contractor's overfed belly, as signalling her contempt towards the subject. It is the first in a series of critical images that Lange made of the big men controlling the land.

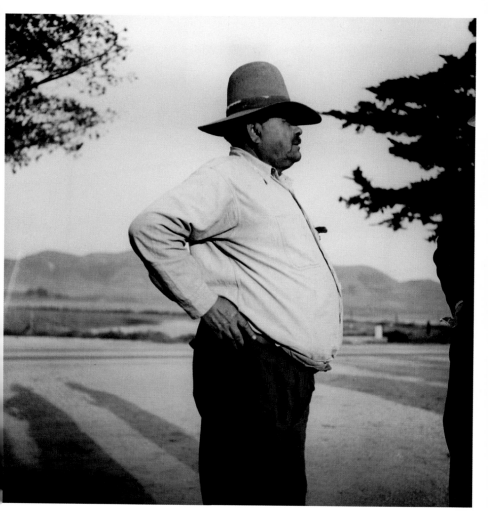

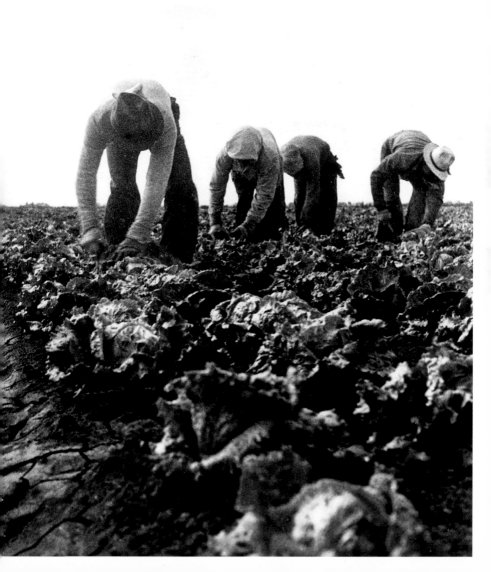

(previous page) Filipinos Cutting Lettuce, Salina, California, June 1935. Lange's low-angle view of this group of Filipinos working in a lettuce field for Japanese owners, serves to monumentalize their labour. It is one of many images by Lange showing bodies bent out of shape by physical toil on the land.

Ditched, Stalled and Stranded, San Joaquin Valley, California, 1935. Lange would occasionally crop her photographs for greater dramatic effect. For this image, she removed the woman in the passenger seat from the picture, focusing instead on the man at the wheel. The image is about being trapped – the car has stalled and the man is stranded – but lacks a sense of courage and resilience that characterizes many of Lange's other portraits of the poor. Here, the subject has been caught off-guard: fear and anxiety are clearly legible on his gaunt, lined face.

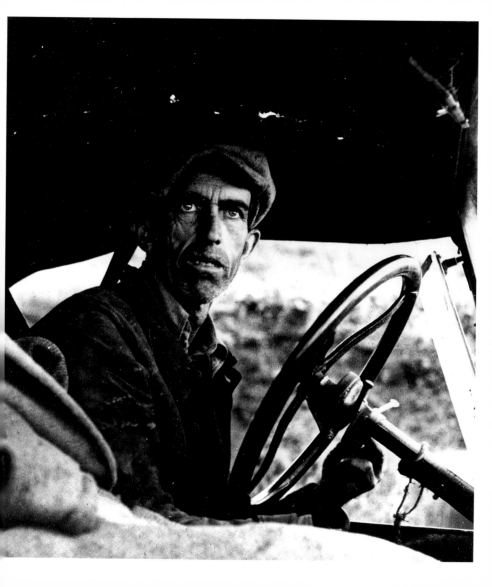

One migrant family hauls the broken-down car of the other to the pea fields at Nipomo, 21 February 1936. This photograph, showing the mutual support that existed between migrant workers, was published in Lange's book *An American Exodus*, made with Taylor. It was accompanied by the quotation: 'Us people has got to stick together to get by these hard times.' It refuses to portray the migrant families as defeated and wasted, and instead strikes a certain note of hope as people help each other to confront their bleak conditions.

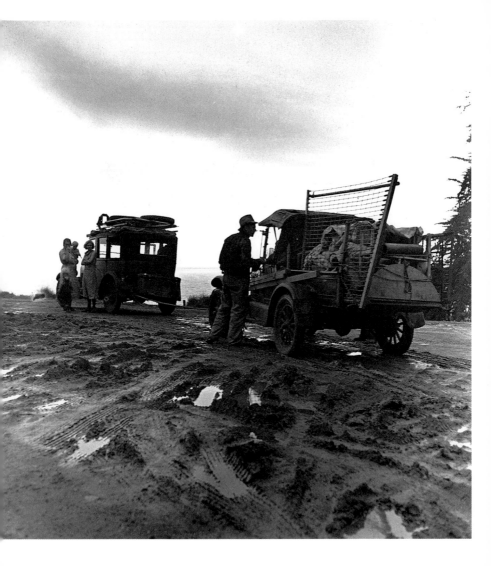

Migrant Mother, Nipomo, California, March 1936. Lange's best-known picture is generally considered to have been the last in a series of six images of this woman and her children in their makeshift tent. In this version, Lange's inclusion of such details as a battered trunk and empty plate serve as clear signs of the family's hunger and homelessness.

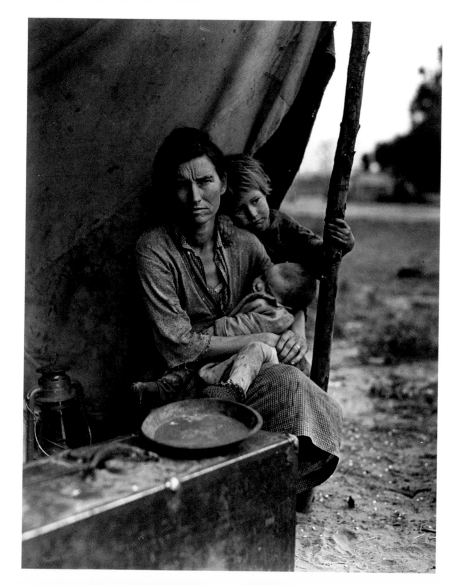

Migrant Mother, Nipomo, California, March 1936. Lange has given us a detailed account of how she took the portraits: 'I did not ask her name or her history. She told me her age, that she was 32. She said that they had been living on frozen vegetables from the surrounding fields, and birds that the children killed. She had just sold the tyres from her car to buy food. There she sat in that lean-to tent with her children huddled around her, and seemed to know that my pictures might help her, and so she helped me. There was a sort of equality about it. The pea crop at Nipomo had frozen and there was no work for anybody. But I did not approach the tents and shelters of other stranded pea-pickers. It was not necessary; I knew I had recorded the essence of my assignment.'

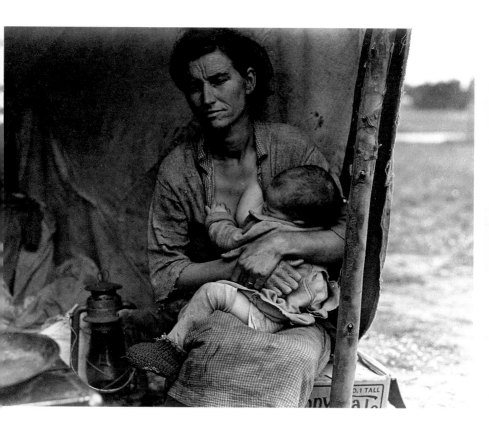

Migrant Mother, Nipomo, California, March 1936. For her final, famous image, Lange removes background detail and hides the distracting countenances of the two children (who are literally pressing upon their mother, hemming her in) by getting them to bury their heads away from the camera. Focus is now on the expression on the mother's face, who, in a moment of withdrawal, looks away from both photographer and children. When Lange took this photograph, she did not notice the detail of a thumb intruding into the foreground. Lange felt this detail spoilt the image and later had the negative retouched to erase the thumb, much to Roy Stryker's disapproval. For Stryker, this was tantamount to tampering with the truth. Lange's insistence on the erasure of the distracting detail confirms the extent to which this classic documentary photograph was very much composed and determined by the photographer.

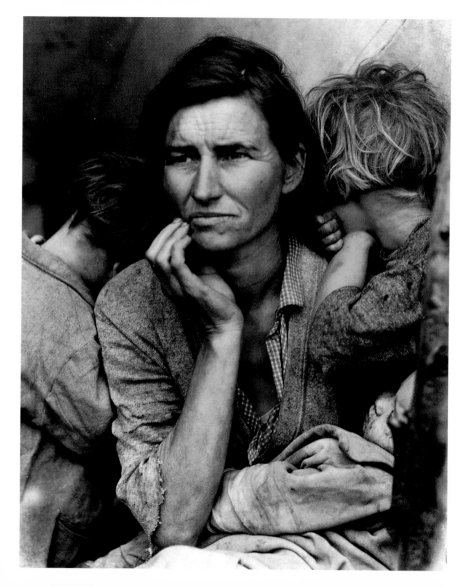

Hoe Culture, near Anniston, Alabama, 1936. The most notable quality of this photograph is the way in which Lange excludes the head of the labourer, focusing instead on his hands and the way in which they grip the primitive hoe. It is, in her words, an image about how man is tied up with the soil. It shows a relationship with the land that is under threat from farm mechanization. In Lange's picture, the details of the farmer's tattered and patched clothing, clearly highlighted by the bright daylight in which the photograph was taken, become significant in relation to the full title for this photograph, which points out, 'The same families that produce the world's cotton crop are often in need of basic cotton products.'

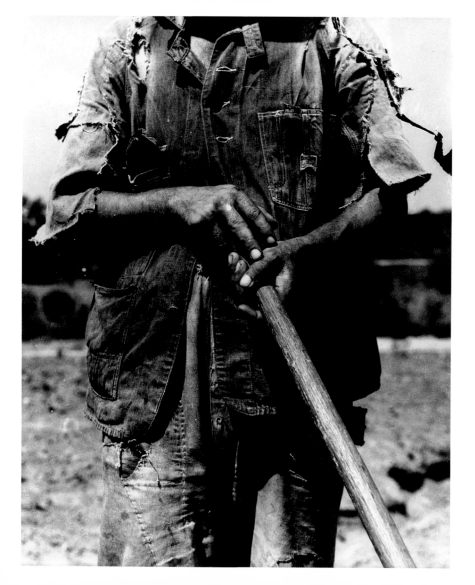

Drought Refugees from Oklahoma, Blythe, California, 1936. 'Dust Bowl' refugees often faced the same prejudices as blacks. According to Lange's biographer Milton Meltzer, stories spread about the lazy, shiftless and irresponsible character of these migrants. Lange's photographs generally belied this myth. Here, she centres upon a migrant family, the breast-feeding mother providing the background to the picture. The foreground is comprised of a close-up of the father, his head propped on his hand and his face signalling a certain resignation, even defeat. In many of Lange's pictures of migrant families, the female is often shown as the stronger of the couple.

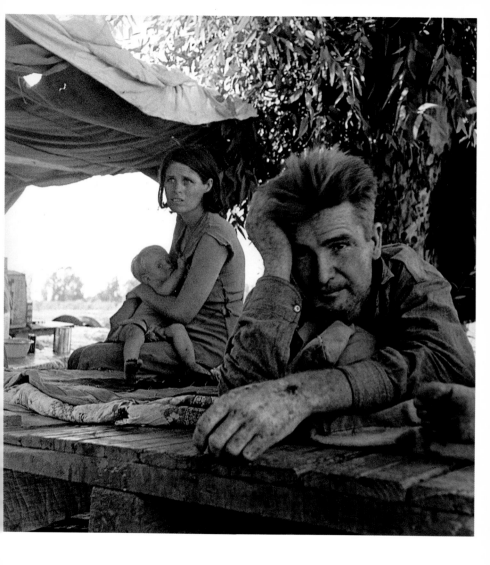

Plantation Overseer and his Field Hands, near Clarkesdale, Mississippi, July 1936. In this well-known portrait, Lange suggests that these black workers are mere property. They are pushed to the background behind the overseer's prize possession, an appropriately oversized car. Lange found the South still caught up in the past and deeply segregated. She told her son Dan Dixon how in this first trip she 'ran up against a problem she'd never encountered before'. 'Earlier I had gotten at people through the ways they'd been torn loose, but now I had to get at them through the ways they were bound up. This photograph of the plantation overseer with his foot on the bumper of his car is an example of what I mean, and this one too [*Hoe Culture*]. In the first, I tried to photograph a man as he was tied up with his fellow, and in the second, a man as he was tied with the land.'

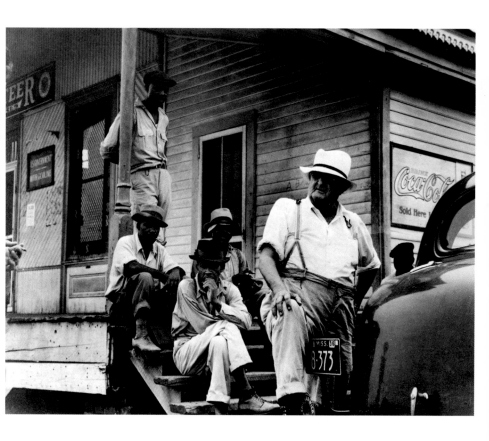

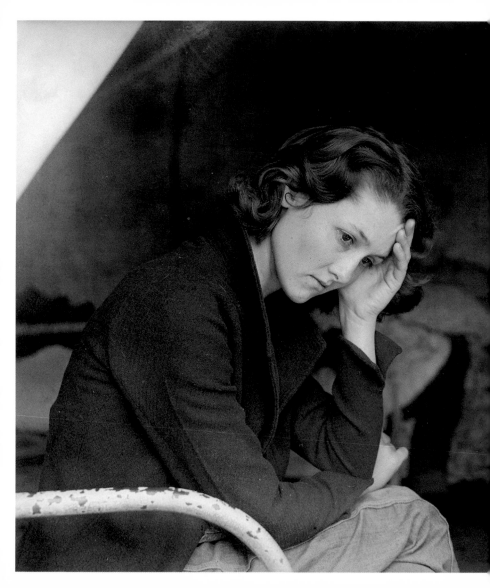

(previous page) **Ruby from Tennessee, Daughter of Migrant Worker Living in America River Camp near Sacramento, November 1936.** Lange supplied Ruby's history in an accompanying caption: 'Ruby is the daughter of a Tennessee family of six who moved to California a little over a year ago. The family is camped here along the America river near Sacramento. They have worked in grapes near Lodi, in walnuts elsewhere, and on a wood job above Marysville. From November to March, they "tuk to the hills" – went back to Tennessee, came right back to California. March is when the cannery starts here, and they have camped here since March.'

Damaged Child, Shacktown, Elm Grove, Oklahoma, 1936. Lange is generally noted for her empathetic engagement with those she photographed. Ralph Gibson, who worked as Lange's assistant in the early 1960s, offers an interesting anecdote concerning this picture. When looking at the photograph, prior to making another print of it, some thirty years after she had taken it, Lange broke down in tears, telling him of how this retarded girl was abused and made an outcast.

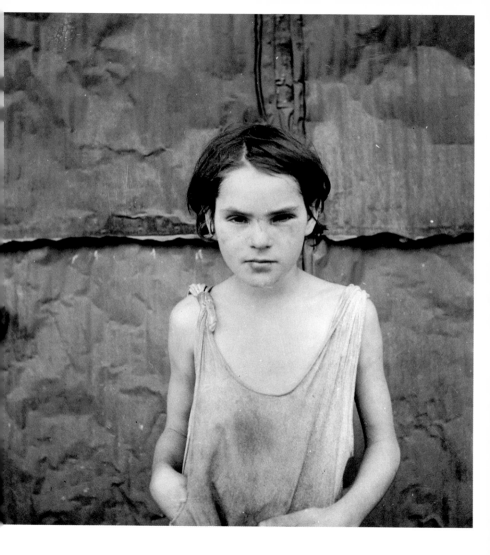

Drought Farmers, Sallisaw, Sequoyah, Oklahoma, 1936. Crouched down before a shopfront, the two men appear to be caught in conversation, sharing stories of their respective hardships. It is an expressive study, attentive to gesture and pose. One holds his hand to his ear and leans towards the other who appears to be talking to him. Crouched down beside them, Lange is not far away, and one imagines her joining them in conversation as she often would for the making of such photos. Indeed, her full title for the photograph includes a quote from them. She tells how 'drought farmers line the shady side of the main street of the town while their crops burn up in the fields. "The guvment may keep us a little I reckon."'

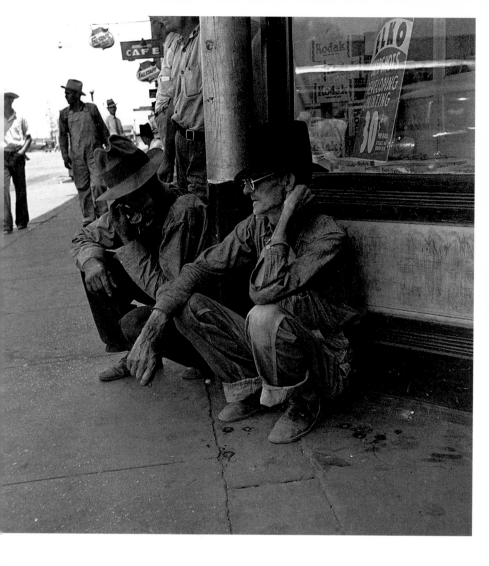

Man Crouched in Field, Waiting for Work on Edge of Pea Fields, Holtville, California, February 1937. Lange's caption informs us that during this season, 'the winter pea crop froze. He had waited for weeks; then more weeks to wait for the second crop.' Lange crouches down in the field to photograph this patient, dignified man. She has spoken of her approach to such picture-making: 'You know, so often it's just sticking around and being there, remaining there, not swooping in and swooping out in a cloud of dust; sitting down on the ground with people ... '

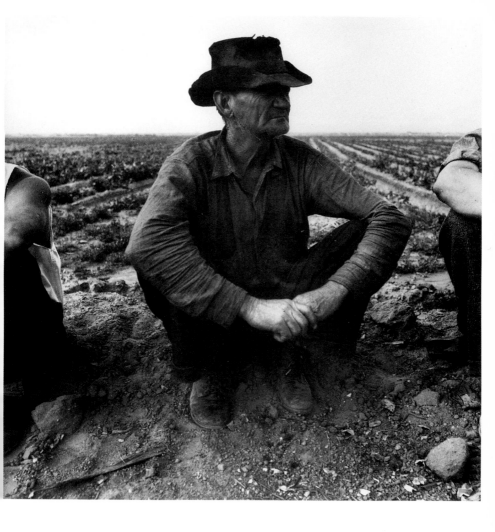

Scene along 'Skid Row' Howard Street, San Francisco, California, February 1937. This striking picture of the homeless sleeping on the pavement provides a strong indictment of the effects of the Depression. The men appear to have no other possessions than the clothes they wear. Taken from a low camera angle, the picture creates the impression that such figures were literally lying under Lange's feet, obstructing her path.

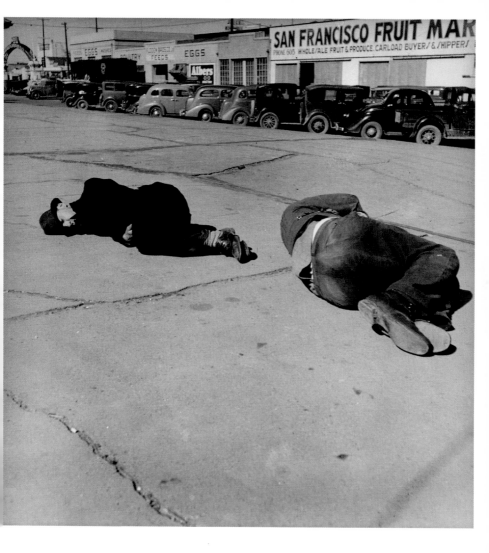

On the Road Toward Los Angeles, March 1937. Lange's indictment of America's class structure is made transparent here as one of Southern Pacific's advertisements extolling the virtues of train travel is ironically set against the slow trudge for work of two migrants. Such juxtapositions were a common ploy of photographers of the Depression era. Margaret Bourke-White, for example, captured a line of flood refugees queuing up for relief in front of another billboard proclaiming that America possessed the 'world's highest standard of living'.

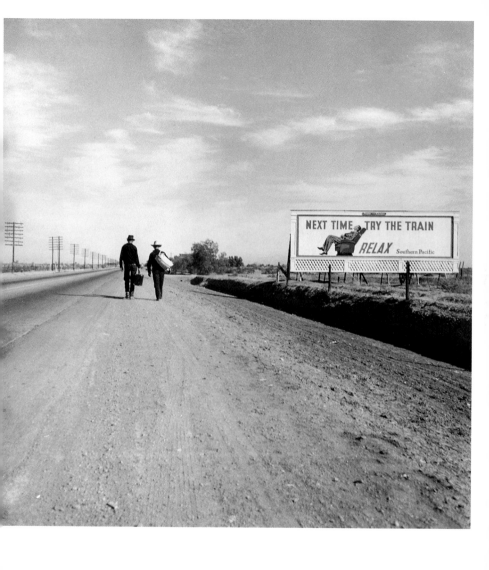

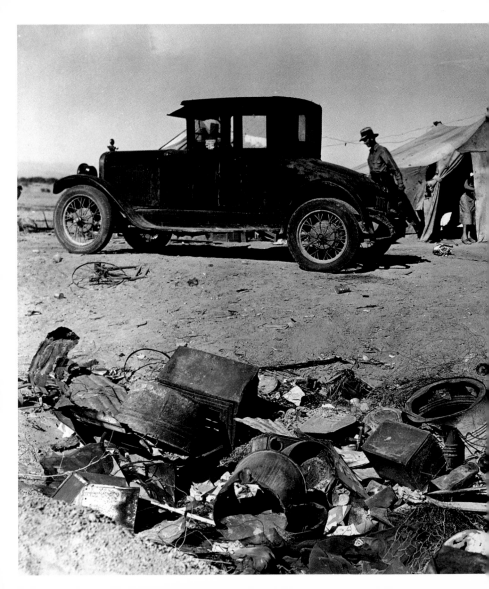

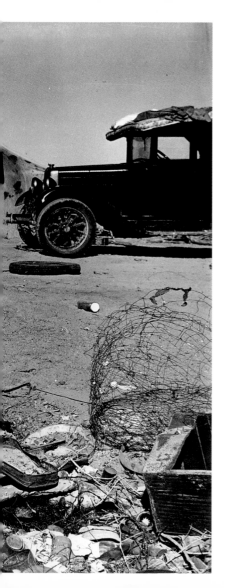

(previous page) **Squatter Camp on Outskirts of Holtville, Imperial Valley, 1937.** Working for the Resettlement Administration, Lange documented conditions in the Imperial Valley, which was in a state of crisis. As she wrote to Roy Stryker: 'What goes on in the Imperial is beyond belief. The Imperial Valley has a social structure all its own and partly because of its isolation in the state those in control get away with it. But this year's freeze practically wiped out the crop and what it didn't kill is delayed – in the meanwhile, because of the warm, no rain climate and possibilities for work, the region is swamped with homeless moving families ... The people continue to pour in and there is no way to stop them and no work when they get there.'

Mexican Migrant Fieldworker, Imperial Valley, California, 1937. Lange has commented on the difficulty of photographing people in the field as opposed to on the street: 'Their roots were all torn out. The only background they had was a background of utter poverty. It's very hard to photograph a proud man against a background like that, because it doesn't show what he's proud about. I had to get my camera to register the things about those people that were more important than how poor they were – their pride, their strength, their spirit.'

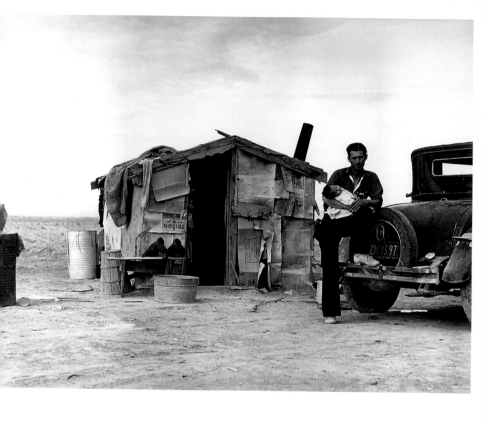

Abandoned Tenant Cabin in the Mississippi Delta, 1937. The sweep of mechanization was turning the best lands over to factory agriculture with absentee owners, managers, day labourers and landless migrants. The alternatives to which Lange and Taylor referred were 'associations of tenants and small farmers for joint purchase of machinery; large-scale corporate farms under competent management with the working farmers for stockholders and co-operative farms'.

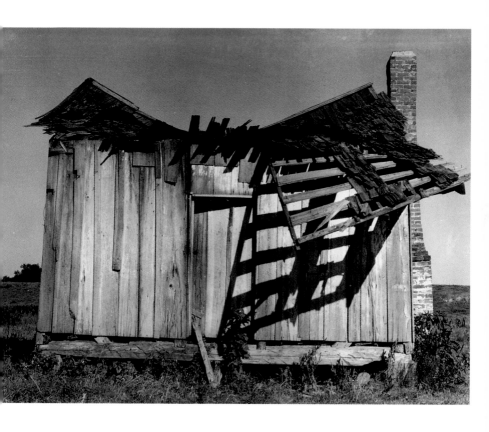

Rex Theatre, Leland, Mississippi, June 1937. Lange represented both white and black communities. This picture, like her later photograph of a negro cemetery (pages 98-9), offers evidence of the racial divisions in the South. Racism was a common political subject of Depression-era photographers, many of whom condemned such long-standing inequalities as they surveyed the country.

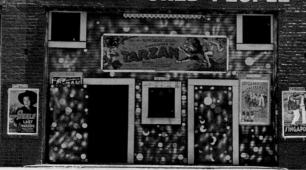

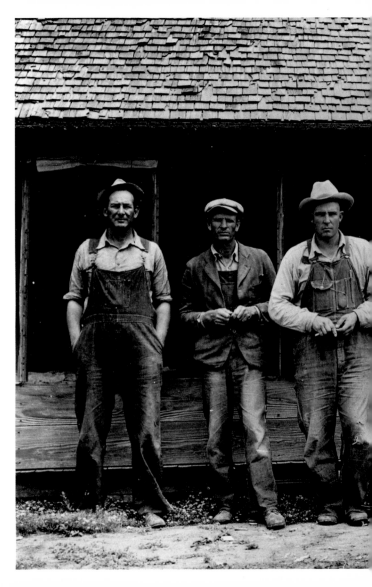

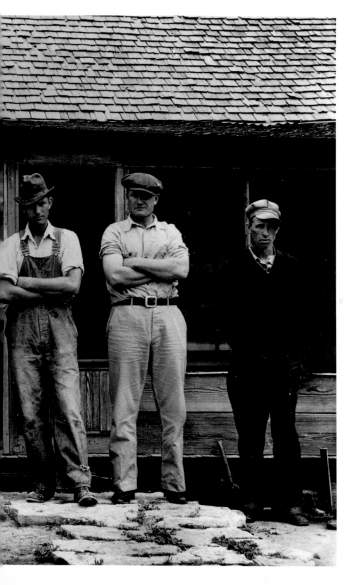

(previous page) Tenant Farmers Without Farms, Hardman County, Texas, 1937. These farmers each supported an average family of four on $22.80 in Works Progress Administration relief. Lange encountered them in a cabin that had previously been occupied by another tenant farmer's family who had fled to California, displaced by large-scale tractor farming. Lange initially cropped out the sixth man in the version of this picture published in *An American Exodus* as she felt he lacked the physical stature of the other men lined up before the camera.

Death in the Doorway, San Joaquin Valley, California, 1938. This formally striking picture, with its framing geometries supplied by the church's recessed doorway and triangular roof, gives a certain dignity to the migrant worker's lonely and anonymous death. As Lange's full caption for the photograph informs us: 'Grayson was a migratory agricultural laborer's shack-town. It was during the season of the pea harvest. Late afternoon about 6 o'clock. Boys were playing baseball in the road that passes this building, which was used as a church. Otherwise, this corpse, lying on the church door, was alone, unattended, and unexplained.'

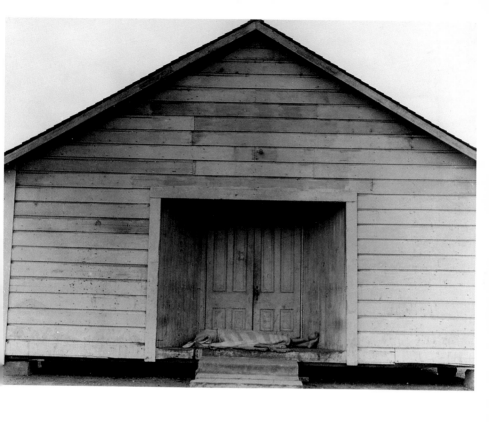

Family on the Road, Oklahoma, 1938. This photograph is accompanied by a quote from a farmer in Lange and Taylor's book *An American Exodus*: 'They're goin' every direction and they don't know where they're goin'.' Taylor's text for *An American Exodus* describes how migration 'is in all directions. Into Oklahoma distressed people pour as through a funnel, going westward, southward, or passing back on their way to Arkansas and Missouri.' The photograph shows a family hitch-hiking from Joplin, Missouri to a sawmill job in Arizona and was taken on US 66 near Weatherford, western Oklahoma. While the father, with head bowed, appears tired and dejected, the mother stands upright, holding her baby in her arms, giving the impression of being stronger, more resilient.

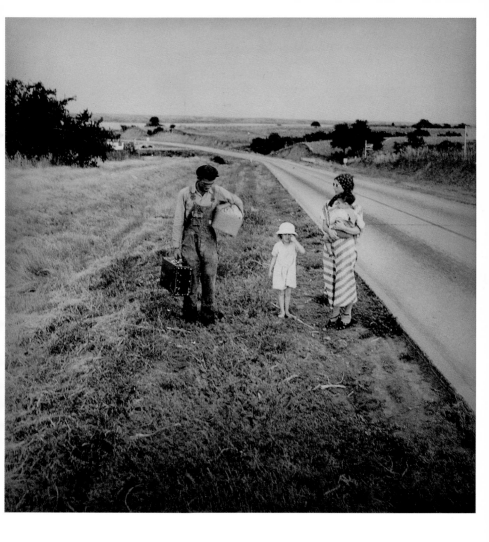

Ex-slave with Long Memory, Alabama, 1938. Stryker had advised the photographers working for him to 'take both black and white but place the emphasis on the white tenants since we know they will receive much wider use'. Lange photographed black farmers with great tenderness. She clearly admired this strong woman who was born into slavery, now living, as another picture by Lange revealed, in a ramshackle home.

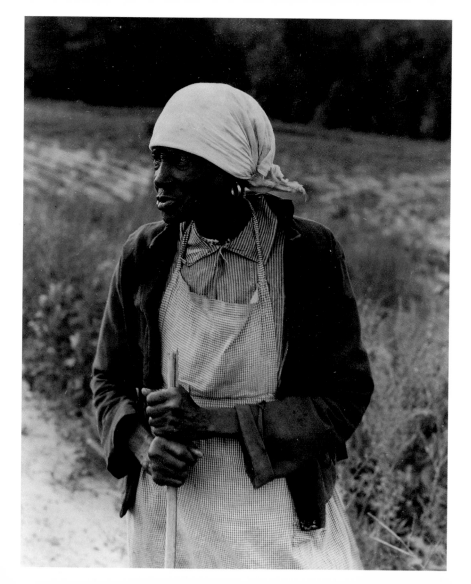

Pea-Picker's Tent, near Calipatria, California, 1938. Lange finds a certain beauty in the temporary homes of these migrant workers. The makeshift, transitory structures, like her portraits of migrants, testify to a certain resilience and determination in the face of hardship. One could contrast the formality of this picture with the waste and disorganization evidenced in her earlier picture *Squatter Camp on Outskirts of Holtville* (pages 58-9).

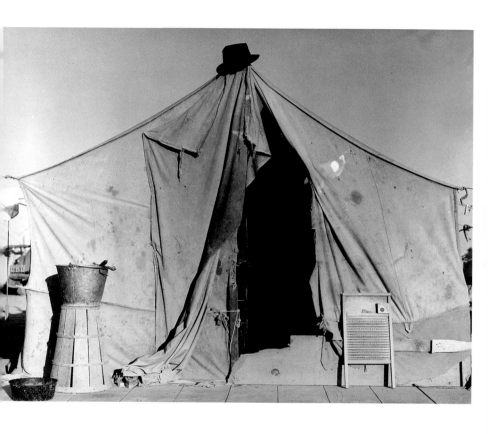

Alabama Farm, 1938. Lange's unusual long-shot photograph shows the family in relation to the land they farm. It is a bleak picture, revealing in the foreground the erosion and infertility of the soil. Erosion of the land became a metaphor for what Lange and Taylor referred to in the subtitle of *An American Exodus* as the 'human erosion' suffered by those forced off their lands by drought and farm mechanization.

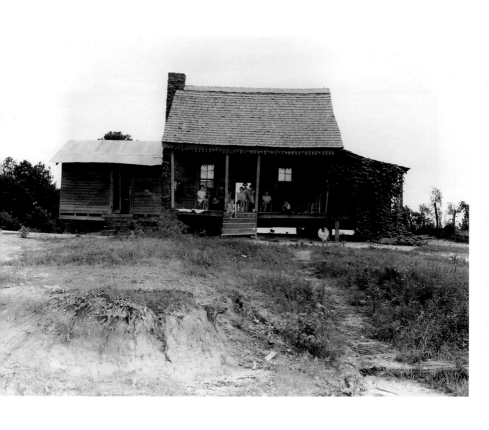

Homeless Family, Atoka County, Oklahoma, 16 June 1938. 'When they arrive in the fertile valleys of the West, the migrants are the most ragged, half-starved forgotten element in our population, needy, the butt of the jibes of those who look down on "fruit tramps", but with a surprising morale in the midst of misery, and a will to work. These people are not hand-picked failures. They are the human materials cruelly dislocated by the processes of human erosion. They have been scattered like the shavings from a clean-cut plane, or like the dust of their farms, literally blown out. And they trek West these American whites, at the end of a long immigrant line of Chinese, Japanese, Koreans, Negroes, Hindustanis, Filipinos, to serve the crops and farmers.' Paul Taylor, *An American Exodus*.

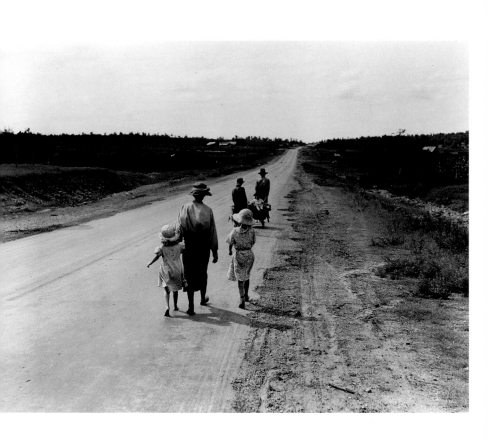

J. R. Butler, President of the Southern Tenant Farmers' Union, Memphis, Tennessee, 1938. Lange was interested in the co-operative efforts of those in the South to free themselves from tenancy and racism. While her portraits often rely on the revealing gesture of the body, a certain stance and posture, in her depiction of the President of the Southern Tenant Farmers' Union, she uses the more conventional 'head and shoulders' portrait. It is a portrait about intellectual power: the presence of her subject is conveyed through the fervent intensity of his wide-eyed look back at camera, while his body appears weak, even fragile. One critic has described his face as 'evangelical'.

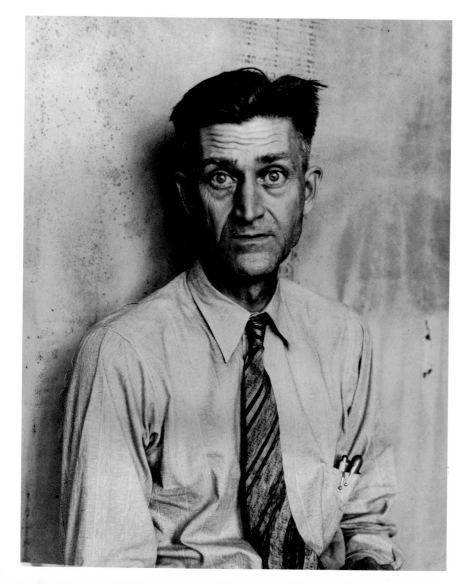

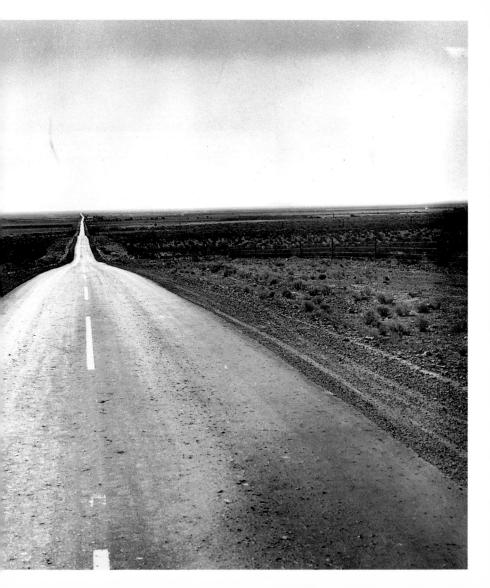

(previous page) The Road West, US 54, New Mexico, 1938. In *An America Exodus*, Taylor talks of the three-centuries-old magnetism of 'an ever-receding Western frontier', a 'tradition which still draws distressed, dislodged, deter mined Americans to our last West, hard against the waters of the Pacific' But this 'new West', this 'new frontier' is bereft of any romantic myths already transformed by farm mechanization. The only opportunity awaiting thos travelling there is to 'obtain intermittent employment in a disorganize labour market'.

Kern County, November 1938. The worker, standing beside an election poste for 'New Deal' Governor Culbert Olson, looks warily towards the camera Lange's full title gives us the man's history: 'He came from an Oklahoma farm i April 1938. Became a migratory farm worker in California, joined the Unite Agricultural Packing and Allied Works of America (CIO) at the beginning of th cotton strike of October 1938, and became the leader of the "Flying Squadron which attempted to picket the large fields of corporation farms by automobil caravans. He drove the first car.'

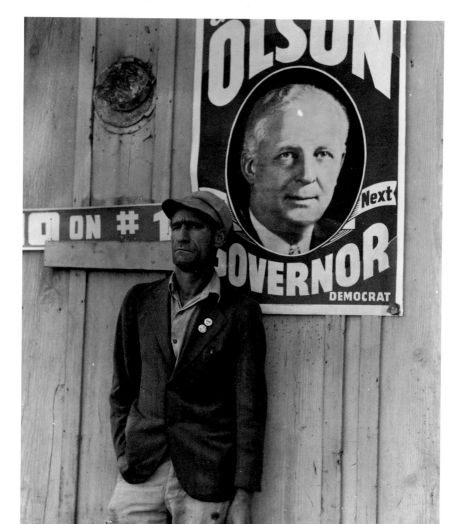

Last West, Gas Station, Kern County, California, November 1938. In this picture of a small, independent gas station during the cotton strike, the hand-painted sign provides a significant symbol of resistance, a humane counterpoint to the corporate billboard advertisements that Lange also pictured.

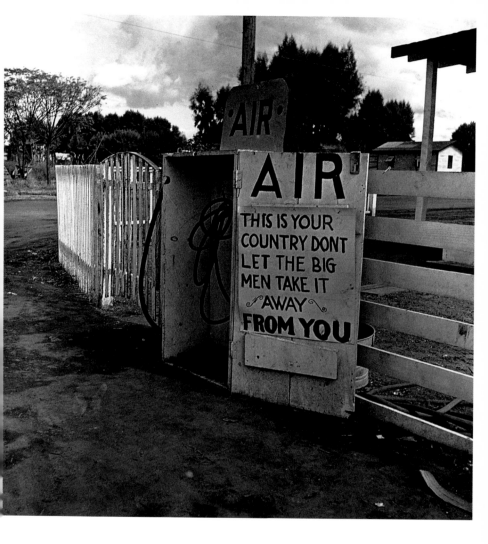

Three Families, 14 Children, US 99, San Joaquin Valley, November 1938. Lange photographed many makeshift camps behind or in front of billboards. Here, she carefully crops the billboard to pick out the detail of the smiling child, a stark contrast to the realities of those living in the hoarding's shelter. As the caption informs us, three families used this billboard as part of their temporary migrant camp during the winter.

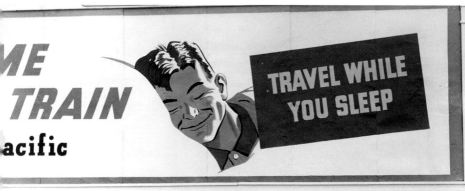

Family on the Road, Midwest, 1938. Milton Meltzer's biography recounts how in May 1937, as she was crossing into Arizona, Lange came across three related families – seventeen people travelling together in four cars. They came from Oklahoma and had followed the potato and cotton crops in California and Arizona. They were now drifting towards New Mexico where they had heard there might be work. 'Milling-about-people' Lange called them. Dogged by bad luck, one family had lost two of its three children from typhoid, which they blamed on the filthy roadside camps of California.

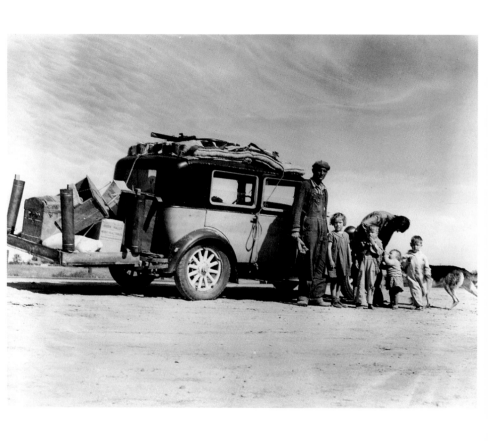

On US 80 near El Paso, Texas, June 1938. This portrait accents the graceful posture of the subject, who stands 'like a queen' as one writer has put it. The picture is accompanied by a quotation from what the woman said to Lange: 'The country's in an uproar now – it's in bad shape. The people's all leaving the farm. You can't get anything for your work, and everything you buy costs high. Do you reckon I'd be out on the highway if I had it good at home?'

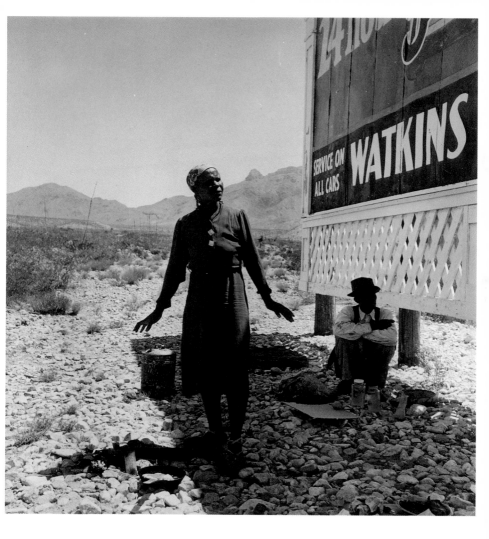

Woman of the High Plains, Texas Panhandle, June 1938. This expressive portrait of a migratory labourer's wife was accompanied by the following quotation from the woman: 'We made good money a-pullin' bolls, when we could pull. But we've had no work since March. When we miss, we set and eat jest the same. The worst thing we did was when we sold the car, but we had to sell it to eat, and now we can't get away from here. We'd like to starve if it hadn't been for what my sister in Enid sent me. When it snowed last April we had to burn beans to keep warm. You can't get no relief here until you've lived here a year. This country's a hard country. They won't help bury you here. If you die, you're dead, that's all.'

94.95

Tractored Out, Childress County, Texas, 1938. Lange wrote to Stryker that 'You couldn't find a better example of exploitation and its consequences in this nation than the changes in plantation life with this tidal wave of tractors.' The photograph shows the way in which farming communities have been destroyed by mechanization. The low-angle shot highlights the repetitive row of furrows extending right up to the empty farmhouse's doorstep. The building appears small and isolated in the machine-worked landscape.

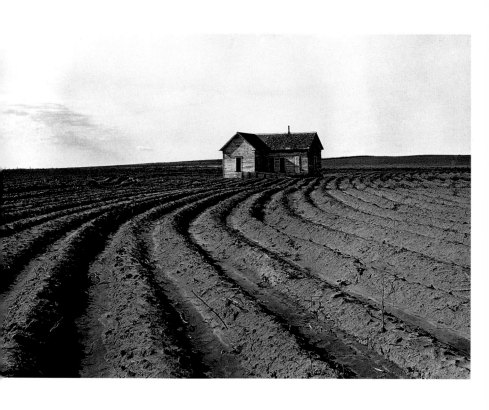

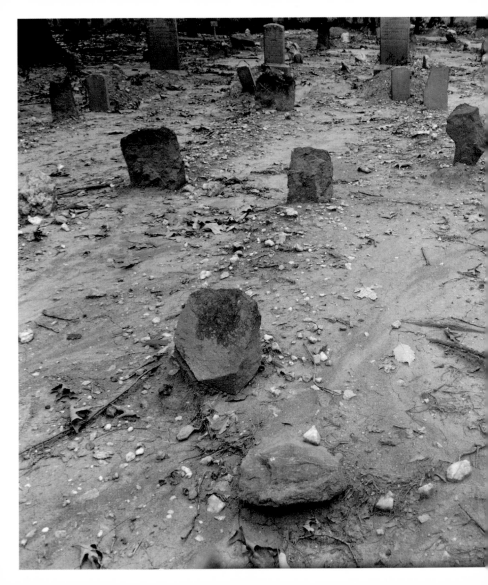

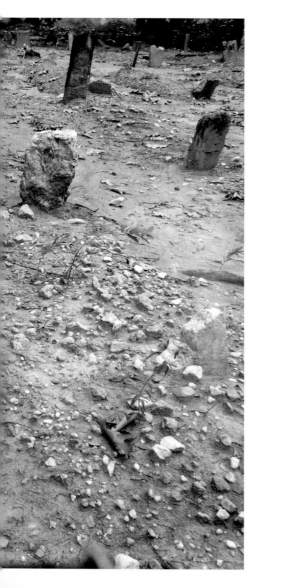

(previous page) **Negro Cemetery at Prospect Church, Person County, North Carolina, July 1939.** This picture testifies to the segregated society of the South and highlights the cemetery's state of neglect and disarray. Lange's caption notes how the graves were in rows with narrow spaces between, and how the red clay, washed by the rains, had coloured the gravestones red. She also notes the misspellings on the grave markers.

Child and Her Mother, Wapato, Yakima Valley, Washington, August 1939. This picture centres on the relationship between mother and daughter. The girl appears trapped, clutching the barbed-wire fence that separates her from Lange. She remains unable to free herself from the watchful, anxious gaze of her mother, whose blurred form is visible in the distance behind her. It is a suggestive psychological portrait, reflecting on the tensions and struggles of adolescence.

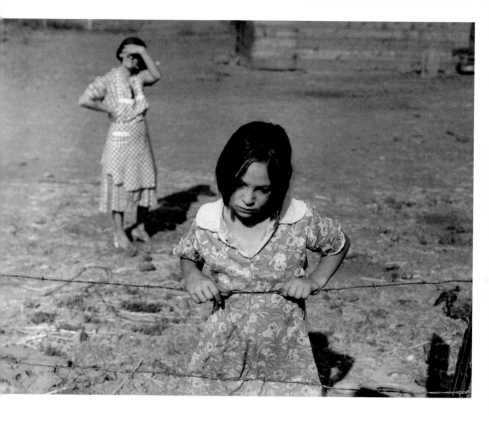

Mother and Children, on the Road, Tulelake, Siskiyou County, California, 1939.
In Taylor's words, 'These people are worth helping! They are down and out, but
they are not the dregs of society. They've just hit bottom that's all.' Once again,
Lange focuses on the maternal relationship: a mother and her children on the
road. Lange's empathy for such individuals was caught up in her ideal of the
family. Lange, according to her son, 'had a profound and passionate feeling for
family. Her own had been shattered by the desertion of her father ... ' However,
at this time, Lange remained a harsh and demanding mother and stepmother
who always put work before her family.

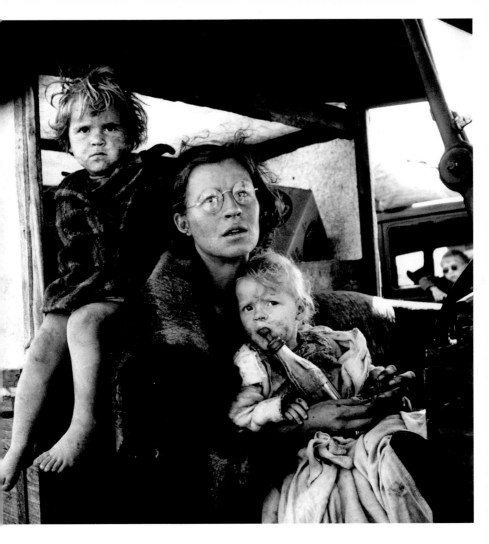

Migratory Cotton Picker, Eloy, Arizona, 1940. As the full caption to this picture reveals, the man is photographed while resting at his 'cotton wagon before returning to work in the field. He has been picking all day.' The hand blocks the subject's mouth and, like the detail in *Hoe Culture* (page 41), speaks of a life on the land. The replacement of mouth by hand is also symbolic of an overriding emphasis in Lange's photography on physical gestures. The man is in fact hiding his bad teeth from the camera.

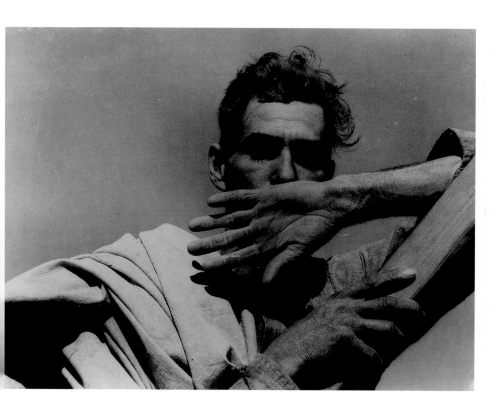

I Am An American, 13 March 1942. When president Franklin D. Roosevelt signed into law Executive Order 9066, the War Relocation Authority (WRA) decided to document the registration, assembly and internment of Japanese Americans. Despite her opposition to the incarceration, Lange was hired by the WRA to document the relocation. She knew many Japanese students and her photographs of their evacuation testifies to her outrage at their appalling treatment. Following evacuation orders, this store was closed. The owner, a university of California graduate of Japanese descent, placed the 'I Am An American' sign on the shop front the day after Pearl Harbor.

Mochida Family, Hayward, California, 8 May 1942. Members of the Mochida family are shown waiting for the evacuation bus. The indignity of their treatment, tagged like the luggage they carry, contrasts with the dignity accorded to them by Lange in this formal, family-group portrait. Lange's full title for the picture speaks of Mochida's job – running 'a nursery and five greenhouses on a two acre site in Eden township. He raised snapdragons and sweet peas.'

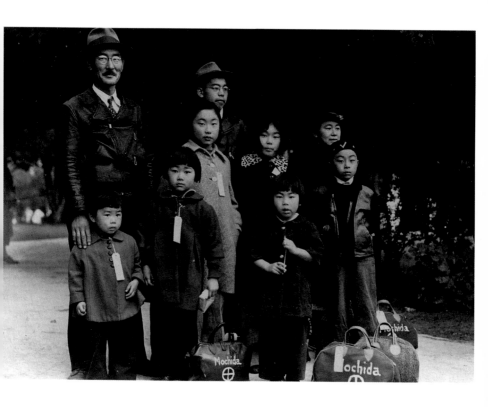

Nisei Soldier, 11 May 1942. The children of Japanese-born immigrants were known as 'Nisei'. This portrait shows a young Nisei soldier who volunteered for army service in 1941. Despite his service, he is treated as a potential threat, an enemy within.

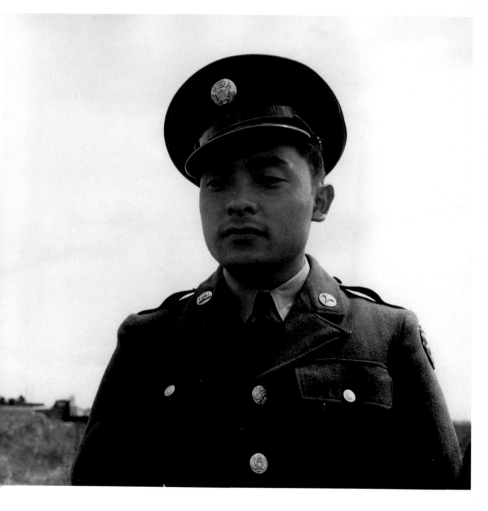

Grandfather, 19 May 1942. 'What I photographed was the procedure, the process of processing,' said Lange of her work for the War Relocation Authority. Here, a grandfather with a label round his neck waits for the evacuation bus. Again, what is most noticeable in this portrait is the calmness and dignity of Lange's seated subject.

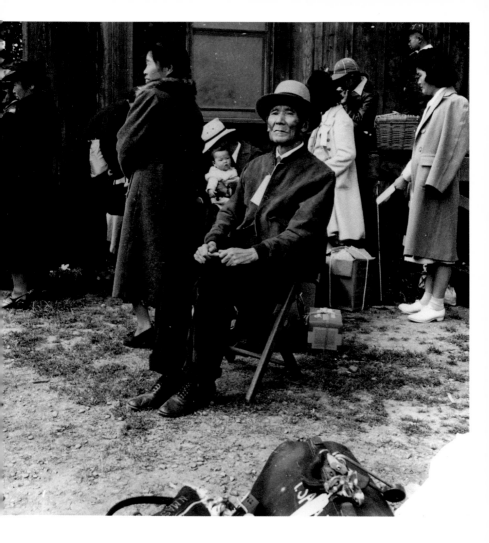

Shipyard Worker, Richmond, California, 1942. At Richmond, Henry Kaiser's recently established shipyards actively produced much of the naval equipment needed for the war and employed many displaced migrants. Lange's brother had a job as a foreman at the shipyard. However, her interest and identification, as shown here, was with women in the workplace. While women had worked alongside men on farms without issue, they met antagonism in the city. In preparing a section on women for her retrospective show at New York's Museum of Modern Art, Lange called attention to two photos that she felt completed her celebration of women's life. One of them is this image of a woman worker in masculine attire whom Lange describes as 'a woman of our generation'.

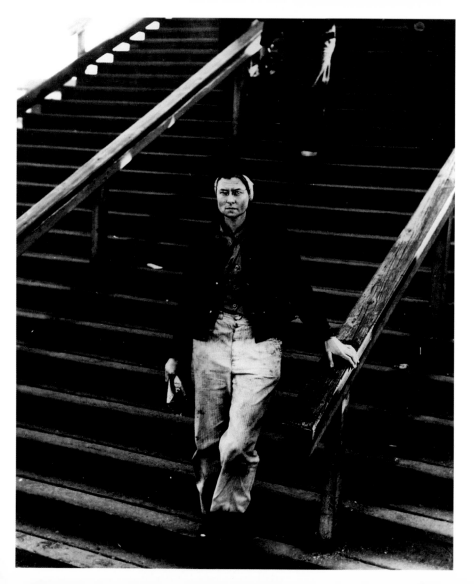

Argument in Trailer Court, 1944. John Szarkowski has referred to Lange's work at this time as carrying a new, 'hard psychological complexity'. The tensions between this young working couple in the photograph speak of the wider tensions between the sexes: women working in factories during the war were often resented by male colleagues.

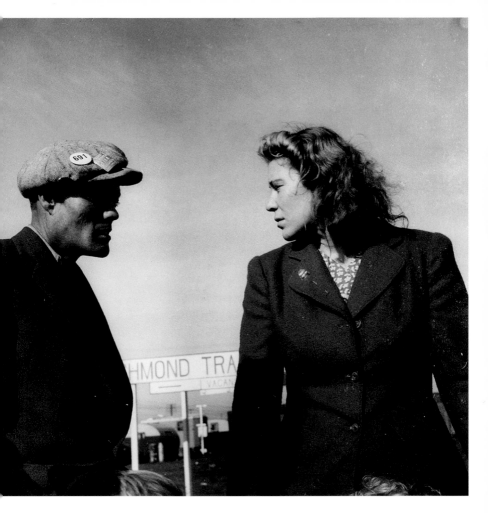

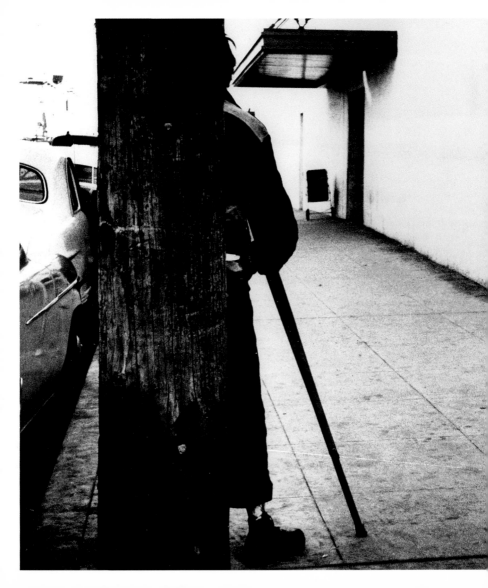

(previous page) **Walking Wounded, Oakland, California, 1954.** It is hard not to see this street picture in connection with Lange herself who suffered from a limp following a childhood bout of polio. She has said, 'There are many, many people on the streets today who are "walking wounded". I see the walking wounded in myself and in my friends. That has certainly been a recurrent theme in my pictures.'

Public Defender in Court, Oakland, California, 1957. In her portraits of Martin Pulich, a Yugoslav-American lawyer, Lange is also drawn to the defendants he represents. This striking photograph concentrates on the expressive gestures of the lawyer and his client, both caught at moments of reflection.

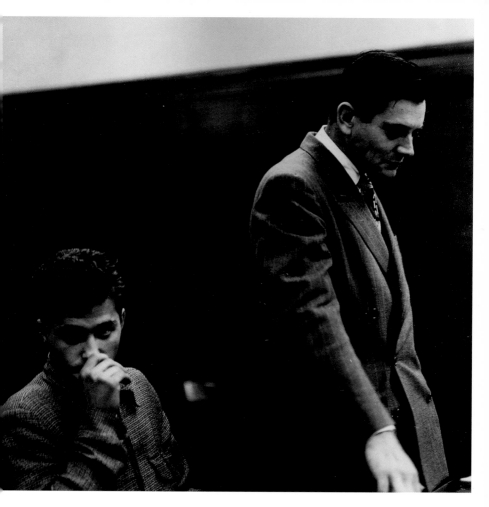

Black Maria, Oakland, 1955–7. Like her 1938 portrait of a policeman, *San Francisco's Street Demonstration on the Edge of Chinatown* (see page 23), this menacing image reveals the signs of power, but here they are faceless, inhuman. Indentations on the doors of the back of this police prison van, picked out by flash light, are suggestive of violence and force.

Terrified Horse, Napa County, California, 1956. The animal's fear and dislocation in this bulldozed land becomes symbolic of the plight of the whole rural community in the fertile Berryessa Valley, destroyed in order to make way for a dam.

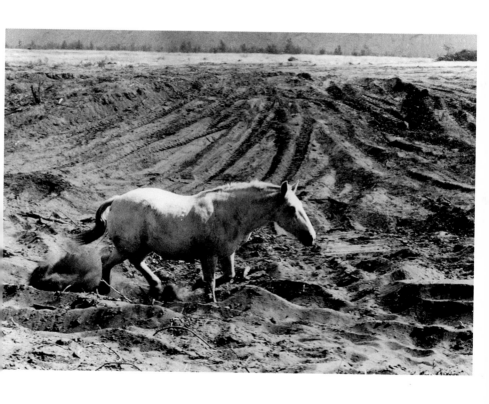

1895 Born 25 May, Dorothea Margaretta Nutzhorn in Hoboken, New Jersey, the child of first-generation German immigrants.

1902 At the age of seven she contracts polio which leaves her with a withered right leg and noticeable limp.

1907 Her father abandons the family. She, her mother and brother move in with her maternal grandmother in New Jersey, where she lives until she is twenty-three.

1913 Graduates from high school and determines to be a photographer. Works with studio portraitists in New York while simultaneously attending teacher training college to appease her family.

1918 Leaves New York with a female friend to travel the world, but their money is stolen in San Francisco, and she is forced to find work there. Starts work in photo finishing, taking orders for developing and printing. Soon after she receives two offers of backing to set up her own portrait studio. Meets with immediate commercial success. During this period, she is introduced to the painter Maynard Dixon, twenty-one years her senior.

1920 Marries Maynard Dixon.

1930 Depression hits. She and Dixon move into their separate studios to save money. Put their children into boarding school.

1933 Decides to venture out on to the street with her camera to document breadlines and protests.

1934 Offered an exhibition of her street pictures. Through this show, Paul Taylor Schuster, professor of agricultural economics at the University of California, asks her to provide him with a photograph to illustrate his article on the General Strike.

1935 Taylor becomes director of the California Rural Rehabilitation Administration and enlists her to photograph the first migrant workers

who flooded into California. Closes her portrait studio and devotes all her energy to the new work. From September, she works for Roy Stryker as a photographer for the Resettlement Administration, later the Farm Security Administration. Begins a personal relationship with Paul Taylor. She and Dixon divorce in October, and in December she marries Taylor.

1940 Publishes *An American Exodus* with Taylor. Work is exhibited for first time at Museum of Modern Art, New York.

1941 Awarded Guggenheim Fellowship, the first woman to receive a photography grant.

1942 Works for the War Relocation Authority, photographing the relocation of Japanese Americans to internment camps.

1945–1950 Work is interrupted by severe and recurrent illness.

1951 Begins actively to photograph again.

1952 Works with Ansel Adams and her writer son Daniel Dixon on 'Three Mormon Towns' assignment for *Life*.

1955 Has nine images included in 'The Family of Man' exhibition at the Museum of Modern Art, New York. Teaches at San Francisco Art Institute.

1956–1957 Records the government's destruction of an old rural community in building the Berryessa Dam.

1958–1959 Travels in Europe and Asia with Taylor, photographing whenever possible.

1964 Works with John Szarkowski to prepare her retrospective at the Museum of Modern Art, New York, which is to open January 1966.

1965 Dies of cancer, October 11, San Francisco.

Photography is the visual medium of the modern world. As a means of recording, and as an art form in its own right, it pervades our lives and shapes our perceptions.

55 is a new series of beautifully produced, pocket-sized books that acknowledge and celebrate all styles and all aspects of photography.

Just as Penguin books found a new market for fiction in the 1930s, so, at the start of a new century, Phaidon **55**s, accessible to everyone, will reach a new, visually aware contemporary audience. Each volume of 128 pages focuses on the life's work of an individual master and contains an informative introduction and 55 key works accompanied by extended captions.

As part of an ongoing program, each **55** offers a story of modern life.

Dorothea Lange (1895–1965) is one of the most famous documentary photographers of all time. In 1935, tired of studio portraiture, she began working for the Farm Security Administration, and created many of the images that define in the popular imagination the Depression and the disastrous migration of farming families to the West.

Mark Durden is an artist and writer. He is currently Senior Lecturer in History and Theory of Photography at the University of Derby He recently curated the exhibition 'Face On' and co-edited the accompanying book.

Phaidon Press Limited
Regent's Wharf
All Saints Street
London N1 9PA

Phaidon Press Inc.
180 Varick Street
New York NY 10014

www.phaidon.com

First published 2001
©2001 Phaidon Press Limited

ISBN 0 7148 4053 X

Designed by Julia Hasting
Printed in Hong Kong

Photographs by permission of:
The Oakland Museum, California;
The Library of Congress,
Washington DC; The Bancroft
Library, University of California;
and San Francisco Museum of
Modern Art.